(*Front cover*).
King, bishop
and knight

(*Left*) King

The ivory carvings that came to ligh coastline of the Isle of Lewis in the O finest group of early chessmen to have discovery is on the south shore of Uig but there are differing accounts of newspaper reported in June 1831 that the find was made by a peasant of the place, whilst digging a sandbank'.[2] Daniel Wilson gave another account[3] which was more detailed and perhaps somewhat fanciful:

In the spring of 1831, the inroads effected by the sea undermined and carried away a considerable portion of a sand bank in the parish of Uig, Isle of Lewis, and uncovered a small subterranean stone building like an oven, at some depth below the surface. The exposure of this singular structure having excited the curiosity, or more probably the cupidity, of a peasant who chanced to be working in the neighbourhood, he proceeded to break into it, when he was astonished to see what he concluded to be an assemblage of elves or gnomes upon whose mysteries he had unconsciously intruded. The superstitious Highlander flung down his spade, and fled home in dismay; but incited by the bolder curiosity of his wife he was at length induced to return to the spot, and bring away with him the singular little ivory figures, which had not unnaturally appeared to him the pigmy sprites of Celtic folk-lore.

The National Museum of Antiquites of Scotland, when it reported the purchase of eleven of the chessmen to the Society of Antiquaries of Scotland in 1888, supported Wilson's version that the sea initiated the process of discovery.[4] However, the Royal Commission on Historical Monuments for Scotland gives credit for this to 'a cow rubbing itself against a sandhill'.[5] There would appear to be no circumstantial account of the find, but by comparing the various versions, one may suggest that an unusually high tide began the work by exposing, or virtually exposing them in the remains of a sand dune or in a drystone structure which had been under the sand dune, and this was brought to fruition by a local who discovered the chesspieces by accident, possibly whilst in pursuit of a stray cow, or by design when he was investigating the exposed chamber. However, no account mentioned what exactly was found in 1831, and we can only suggest the minimum contents of the hoard by reference to what exists today, bearing in mind that the pieces discovered may not all have been acquired by museums.

Ninety-three pieces are known today. There is one belt buckle, fourteen plain draughtsmen, and sixty-seven chessmen, all of which have been in the British Museum since 1831, and another eleven chessmen which were acquired by the National Museum of Antiquities of Scotland in 1888.[6] Concerning those acquired by the British Museum, a record of 8 December 1832 states '67 Chessmen carved about the XIIIth century from the teeth of the Walrus, found in the Isle of Lewis . . . ' (These were bought for £84 in November 1831, they had been offered for £105). Altogether, then, seventy-eight chessmen from Lewis are now divided

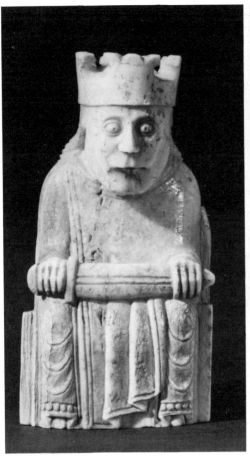
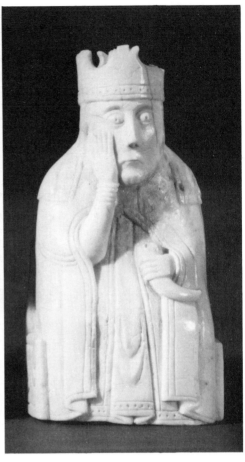

1. King and Queen from the same set

between London and Edinburgh. All these pieces, belt buckle and draughtsmen as well as the chessmen, are carved in morse ivory, that is, the tusks of the walrus which was much used by sculptors in the Middle Ages in those countries bordering on the northern seas.

Captain Thomas reported in 1863 an account,[7] obtained from the manuscripts of the legends and traditions of the Lewis made by a Mr Morrison of Stornoway who had been 'for many years a resident of the parish of Uig, and was intimately acquainted with the folk-lore of that district'. This story may merely demonstrate how short the gestation period for a folk legend need be.

George Mor Mackenzie was tacksman of the farm of Balnakill and other lands, in the parish of Uig; and at one time he had yeld cattle at a remote shieling in the southern end of the parish, called Aird Bheag, near the entry to Loch Resort. Mackenzie employed a young man to herd the cattle there; and on a stormy night a ship was driven ashore at Aird Bheag. On the following morning, Mackenzie's herd saw from a hiding-place a sailor swimming ashore with a small bag upon his back. The herd pursued

2

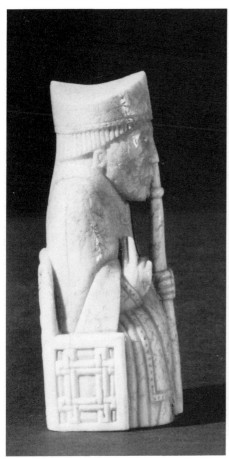
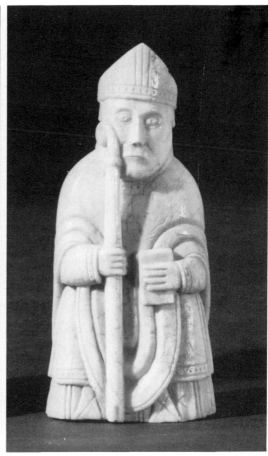

2. Two bishops

the sailor, overtook and slew him without ceremony, hoping to find riches and money on him. Burying the sailor in a peat-moss, he went to Balnakill to inform his master of the fate of the ship, advising him to kill the crew, and possess himself of the wealth the ship was supposed to contain. But Mackenzie reprimanded his herd for this barbarous advice, and directed him by no means to do them harm, but to conduct the survivors to his house. So the crew all safely arrived at Balnakill, excepting the sailor whom the herd had murdered. Mackenzie showed all manner of kindness to the strangers, who stayed about a month with him, and in that time they saved as much from the ship as more than satisfied Mackenzie for their keep.

When the shipwrecked seamen left the country, the wicked herd, always afraid of detection, though living in a remote corner of the parish, went to where he had concealed the bag for the sake of which he had murdered the sailor, to examine the contents. These turned out to be carved relics of various descriptions, and fearing the figures might be turned to proof against him, he travelled not less than ten miles in a dark night, and buried the carved images in a sand-bank in the Mains of Uig. This herd never prospered thereafter, but went from bad to worse, until, for his abuse of

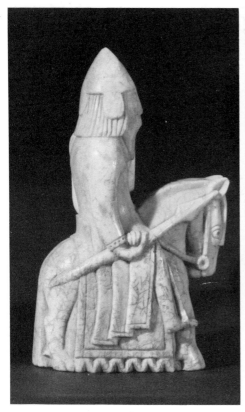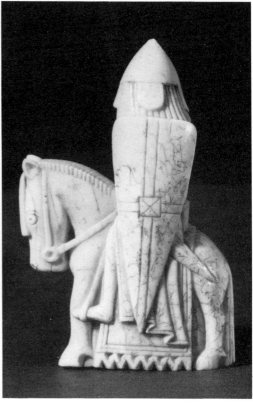

women, he was sentenced to be hanged on the Gallows Hill, at Stornoway. When he was brought forth for execution, he told of many wicked things which he had done and, among others, how he had murdered the sailor, and where he had buried the images.

Thereafter, in AD 1831, Malcolm Macleod, tenant of Penny Donald, in Uig, found upwards of eighty of these carved relics; and those images were sold in Edinburgh by the late Captain Ryrie, for L.30, for the above Malcolm Macleod.

Chess is a sophisticated game which is much used in literature and the cinema as a shorthand in the establishing of character. Chess players are seldom depicted as homely, passionate or intuitive, but rather as clear-headed, rational, sometimes cold and even ruthless when need be, qualities which are thought to be advantageous in the waging of war. In fact, chess was almost certainly invented in India, perhaps in the fifth or sixth century of our era and was called *chaturanga*, a Sanskrit word which meant four divisions, that is, of an Indian army of the day. Chess can therefore be considered as the army game, a game with one-and-a-half thousand years or so of tradition behind it, a game which has become nationalised in many countries of the world, the majority having their own men, arrangement of the board, and rules. The earliest references to chess

4

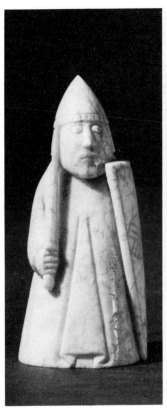
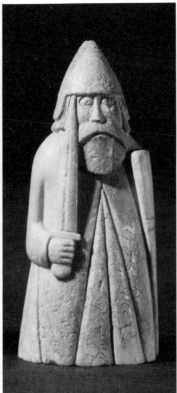
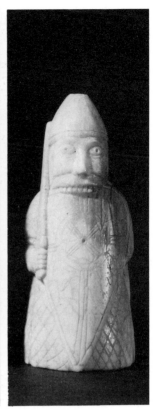

4. Three warders

in literature have been found in Sanskrit writings of the seventh century. The first of them is in the romance Vasavadatta, dating from the beginning of the seventh century, by Subandhu,[8] who described the rainy season thus, 'The time of the rains played its game with frogs for chessmen which, yellow and green in colour, as if mottled with lac, leapt up on the garden-bed squares'.

Chess, then, is a game which initially symbolised a battle between two Indian armies, each governed by a king, aided by his general or minister, and consisting of two elephants, two horsemen, two chariots and eight footsoldiers, and the moves that these pieces were allowed to make on the board symbolised the different degrees of manoeuvrability of the four divisions. Also embodied in the new game of chess were the strategy, aim and decision of the Indian army of that time.

From India this new game spread far, due to its own excellence and the travels of players. Nearly all countries made significant changes in the rules as well as in the pieces themselves, so there are many different games of chess that can be played: Japanese, Malay, Mongolian, Chinese and so on through nearly every country. Even the Yakutat Indians of Alaska, it has been claimed, played a chess which showed no European influence.[9]

By AD 600 chess had made its earliest advance, moving from India into Persia. After the Islamic conquest of that country, the Muslim world

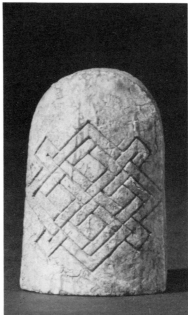

5. Three pawns

acquired it, and it was from Muslim North Africa, perhaps through the intermediary of conquered Spain, that it reached the Christian West. One of the first European references to the game is found in the will of the Count of Urgel in Northern Spain who left, in the year 1010, his chessmen to a convent of St Giles. It is sometimes suggested that it was with the Norman Conquest that the game was first introduced into England. Certainly the very word 'chess' and the usual English names of the pieces are of Norman introduction. Nevertheless, three independent manuscripts, though admittedly of a date somewhat later than Cnut, portray him as a chess player[10], and in the British Museum, as well as the Lewis Chessmen, are the tenth-to-eleventh century Anglo-Saxon pieces from Witchampton, Dorset.[11]

Europe, like most other areas which had acquired Indian chess, altered some of the pieces and also strengthened some of the moves. In England, the Indian king continued as 'kyng', the general or minister became the 'quene' or 'fers' (coming from the Arabic firz or wiseman), the elephant became 'alfin' the bishop (from the Arabic al-fil or elephant), the horseman became 'knyght', the chariot became 'roc' (from the Arabic rukhkh or chariot) and the footsoldiers became 'poun' or pawn (from the medieval latin *pedo* or footsoldier). It is interesting that the word chess comes from the Arabic shāh or king, and checkmate from shāh mât, 'the king is without resource'.

The Lewis chessmen have been described as 'the outstanding ancient chessmen of the world',[12] an extravagant claim but one amply justified by their quality, vigour and humour as well as by their quantity, for few examples survive at all from the Middle Ages, and the majority lack

appreciable quality. In this hoard we have, presumably, the remains of four complete sets, for between London and Edinburgh there are 8 kings, 8 queens, 16 bishops, 15 knights, 12 rooks and 19 pawns. Apart from 45 pawns missing, the only other losses are 1 knight and 4 rooks.

With the exception of the pawns, all the pieces are represented naturalistically. The kings, queens and some of the bishops are seated on thrones, the backs and sides of which are decorated with intricately carved panels which will be examined later. The remainder of the bishops are standing. The kings wear crowns and hold swords across their knees with both hands. The queens, also wearing crowns, all have their right hands pressed to their cheek and while the kings may look solemn, the queens seem aghast (1), *(see also inside front cover)*. The bishops hold a crozier of simple volute form, the head of which presses their cheeks. Some croziers are held in the left hand, others in the right, and some are grasped by both hands. A few of the bishops are blessing with their right hands, and others hold books. They all wear mitres (2). The helmeted knights are all mounted and wear on their left sides swords. On their left arms are large shields with geometric blazons out of which idea heraldry was to develop, and they hold spears in their right hands (3). The rooks or warders are footsoldiers, nearly all of them helmeted and all armed with swords and shields again adorned with primitive blazons (4). And finally, the pawns, which are abstract, are of two kinds. The majority are like polygonal obelisks (5a) and the others more like tombstones. Some of the latter are decorated with geometric or foliate decorations (5b and c).

As sculptures, the chessmen are brilliant examples of twelfth-century design. They have none of the delicacy and intricate detail of small-scale sculpture, rather they are conceived as compact heavy forms and imbued with a remarkable presence out of all proportion to their miniature size. The tallest is only 4⅛ inches high. The chessmen are robust, as is essential with objects intended for much handling. The details are kept within the forms and do not project as fragile, breakable protrusions. For instance, the spears of the knights lie along the flanks and necks of the horses, the swords of the rooks lie along their shields and faces, and the croziers of the bishops are similarly flush with their bodies and cheeks. Even the legs of the horses are part of the solid base of the pieces. Every chessman has vitality, and variety too, for no two pieces are alike, and there is, for us at least, a sense of humour. The mounts ridden by the knights are not horses so much as stocky, docile ponies with long and almost blinding forelocks; and several of the warders glare as they bite, with huge teeth, the tops of their own shields in the manner of berserks.

Today the chessmen are plain uncoloured ivory, but this was not the case when Frederic Madden published them in 1832. He says that 'for the sake of distinction, part of them were originally stained of a dark-red or beet-root colour; but from having been so long subject to the action of the salt-water, the colouring matter, in most cases, has been discharged'.[13] So it would appear that some of them at least retained traces of colour, and this agrees with what we know about draught pieces, that the sides were

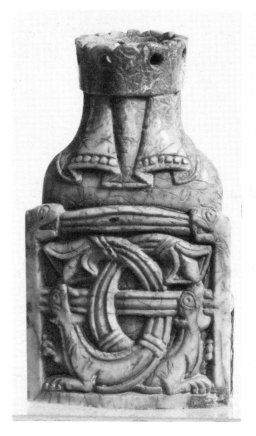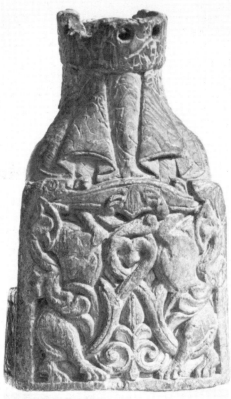

told apart by colour, usually either by staining red or by smoking brown.

By the twelfth century chess had become in Europe the most popular game amongst the upper classes, and was played by women as well as men. Petrus Alfonsus, the physician of Alfonso VI of Castile maintained, in his *Disciplina Clericalis* of about 1110, that chess was one of the seven knightly accomplishments. The game was so popular that it was frequently banned by the Church, the prohibition sometimes extending to monastic orders only, sometimes to all the faithful. Nevertheless, many manuals of strategy were produced by monks, and medieval sermons survive whose symbolism was taken not from Holy Writ but from the game of chess.

Medieval chessboards were substantial affairs compared with their modern cardboard and rexine counterparts. The earliest boards were not chequered, but by the twelfth century, the date of the Lewis chessmen, this helpful innovation is mentioned in literature as something new, the combination generally used being apparently red and white. Black and white and grey and white are also mentioned.

From the size of the Lewis chessmen one will gather that any board to accommodate them would have to be much larger in width and breadth than a modern board. Medieval literature often impresses us with

6(a and b). Decorative panels on the thrones of two queens

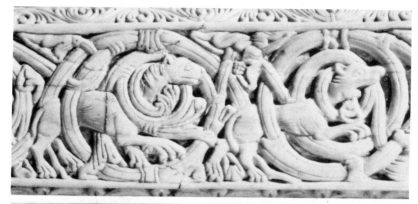

6(c). Section of a walrus ivory tusk with beasts intertwined in a foliage scroll

6(d). Walrus ivory fragment found at Munkholm, near Trondheim in Norway

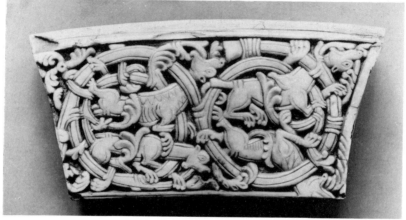

descriptions of our hero's board, made of gold, or gold and silver, gold and ivory, or just ivory. Such boards must have been of great rarity even then. The board was an object of which to be proud and there are references which tell us that when not in use, the board might be found hanging on the wall by a ring. Lesser boards, no doubt the majority, were made of wood or metal and, from time to time, they are mentioned in romances as being used as weapons of attack and defence.

The coherent and self-confident style of the Lewis chessmen is virtually without parallel. Indeed there is much uncertainty about the origins of the chessmen, both about their style and their date. This is due to a lack of comparable surviving material. There seem to be no counterparts for the very simply draped, compact and expressive human figures with their strong and forceful faces. However, comparisons can be found for what might be considered minor or incidental details of the chessmen. Most significant are the ornamental panels which decorate the thrones of the kings, queens and some of the bishops (6-9). These panels of foliage, some of them inhabited by beasts, have close similarities with other sculptures. They belong to a group of carvings which employs the same motifs and in the same manner. The group was centred in Scandinavia and dates from the middle years of the twelfth century.

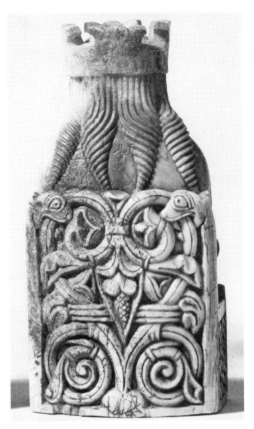

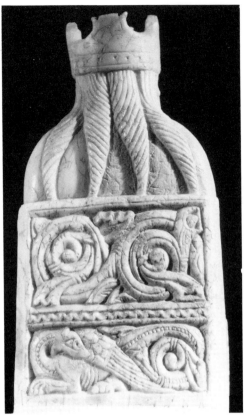

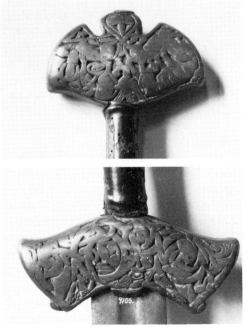

7(a) *Top left.* Decorative panel with 'cone and pouch' motif on the throne of the king shown in (1)

7(b) *Below left.* Section of walrus ivory tusk with foliage decoration showing the 'cone and pouch' motif

7(c) *Below right.* Two walrus ivory sword fittings, a pommel and guard. The 'cone and pouch' motif occurs at the top of the pommel

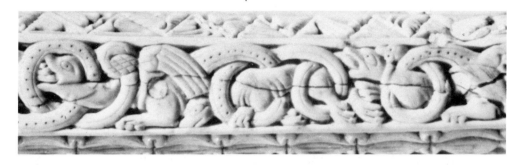

Frederic Madden, who published the chessmen for the first time,[14] suggested that they were of Icelandic origin and that they dated from about 1150. This suggestion, considering that Madden published his article in 1832, is remarkable. And when the chessmen were most recently discussed in print in 1960 by Professor Peter Lasko,[15] he suggested that they should be dated not later than the third quarter of the twelfth century. Such early datings appear to be more accurate judgments of the age of these admittedly enigmatic carvings than the date of about 1200 which is usually given to them. In the past they have also been dated to the thirteenth century, and once even to the seventeenth century.

The other carvings in the group around the Lewis chessmen are, firstly, four ivories. One is a fragment of walrus ivory[16] which was found at Munkholm near Trondheim in Norway in 1715, and is now in the National Museum at Copenhagen (6d). One end of this carving has been cut away, and it may once have been adapted for use as a crozier. Two more, also of walrus ivory, are in the same museum. They are sword fittings, a pommel and a hilt,[17] whose only history is that they come from the Royal Danish collections and are fitted to a blade which is probably of fifteenth-century date (7c). The last ivory[18] is of walrus tusk also, and was acquired by the British Museum in 1959. Its original use is not certain and no previous history is known prior to its acquisition by the Museum (6c, 7b, 8b).

Secondly, there are three Norwegian wooden stave churches. At Urnes,[19] it is the nave capitals that are of interest (9a, b), at Ulvik[20] it is the west doorway (*inside back cover*), and at Hopperstad[21] the north door to the choir (10).

And thirdly, there are two doorways at Ely Cathedral, the Monks' Doorway[22] (11) and the Prior's Doorway[23] (12a, b). It is helpful to bear in mind that during the twelfth century there was still a flow of artistic ideas crossing the North Sea in both directions between England and Scandinavia, and that the sea was in no way a barrier to such exchanges.

Certain sculptural details are common to all the carvings mentioned. Other stave churches and some wooden furniture also have details common to the group but not as significantly as do the four ivories, the three stave churches and the two doorways mentioned above.

Illustrations 6 to 8 show how closely related the four ivories are to the decorative panels on the backs of the thrones of the chessmen. The overall

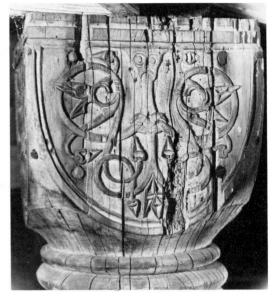

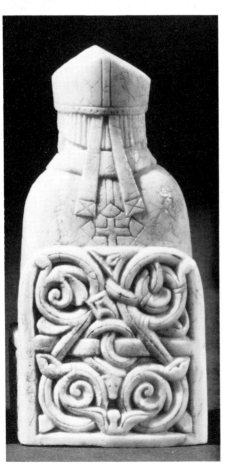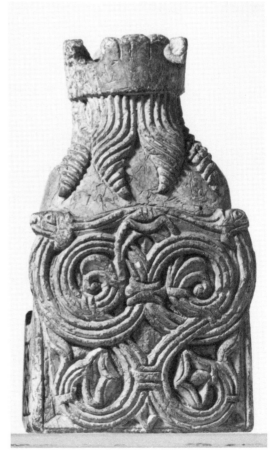

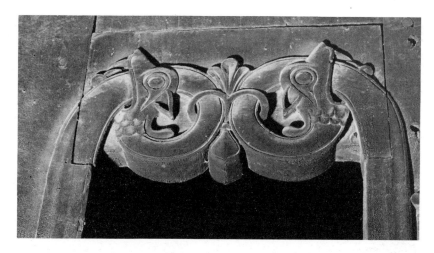

9(a and b) *Left, top.* Wooden nave capitals from the stave church at Urnes, Norway

9(c) *Far left, below.* Decorative panel on the throne of the bishop in (2) (left).

9(d) *Left, below.* Decorative panel on the throne of a king

10. Detail of the north door to the choir from the stave church at Hopperstad, Norway

impression of the closely interlaced, fleshy foliage, often with beasts intertwined in it, is very similar. The heads of the beasts with their fleshy jaws biting the foliage, and their large tear-shaped eyes, as well as their long, soft-toed feet, are all very close in style (6). One of the most characteristic features of this group of ivories is a bud or cone enclosed in a leaf as in a pouch (7). Details such as the triple-ringed bracelet around the scroll and the single or double lines engraved in the scroll or outlining the beasts are all similar. Winged dragons also are found on two of the pieces; the line of small punched dots down the centre of the scroll, visible on the two sword fittings, occurs again on the long bodies of the dragons, both on the walrus tusk and on the back of one of the kings (8).

Illustrations 9 to 12 show the same elements from the stave churches and from the doorways at Ely, and making allowances for the different materials of ivory, wood and stone, and for the difference of scale between small ivories and monumental sculpture, one can see again how similarly they have been treated.

Now the carvings which have just been compared to our group of ivories at Ulvik have been dated to about 1140-50 by Dr Martin Blindheim,[24] and at Urnes and Hopperstad to the 1150s or later by Erla Bergendahl Hohler,[25] while the sculpture of the two doorways at Ely has been dated to about 1135 by Professor George Zarnecki.[26] Furthermore, the latter has shown how the sculptor of the Ely doorways was influenced by the Viking art of Scandinavia.

The Lewis chessmen have been compared with four ivory carvings, three of which have been in Scandinavia for a long time; with three Norwegian churches, and with Ely Cathedral, where the sculpture of the two doorways betrays a knowledge of Viking art. It may be assumed that the chessmen are Scandinavian too, and that they are products of the same Scandinavian artistic *milieu*. Where they were actually carved and the nationality of the artist we cannot know, but what matters is the dominant cultural influence on an artist, not his nationality, nor the place where a work is done. In this context, the chessmen are Scandinavian.

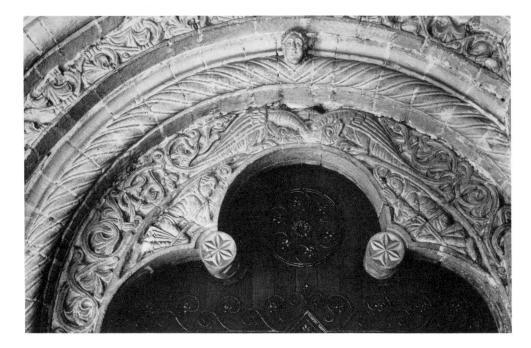

There are two other chessmen which were carved by the same workshop as those found on the Isle of Lewis. They are a knight[27] in the Bargello in Florence and a warder[28] in the National Museum, Stockholm. We have no provenance for the former, but the latter was found in Gräsgard in Öland, and this is futher support for the Scandinavian origin of the whole group of ivories.

The comparative dates of the monumental sculptures are about 1135 and about 1150-70, which gives a period of thirty-five years, from 1135-70, within which to anchor the group of ivory carvings. Certainly it would seem justifiable to date the ivories towards the end of this period or at least into the second half of the century, postulating a slight time lag between monumental and minor sculpture, though when one is dealing with sculpture of the quality of the 'crozier', the walrus tusk and the chessmen, it is probably unwise to assume that the minor sculpture must lag behind the monumental, as opposed to actually leading it and acting as its inspiration.

One might even be willing to date the chessmen close to the Ely doorways in the 1130s but while the armour of the knights and warders does not give us sufficient guidance in the matter, the mitres worn by the bishops are of significance (2). It is normally assumed that the mitre was not worn with the points to the front and back until towards the end of the twelfth century, as distinct from the previous fashion of wearing the points to the sides; but it has been claimed that the new fashion was already current in France by about 1144,[29] and in England by very soon after 1153.[30] The question of the mitre is important for the dating of the chessmen and it would be wise therefore to place them late, bearing in

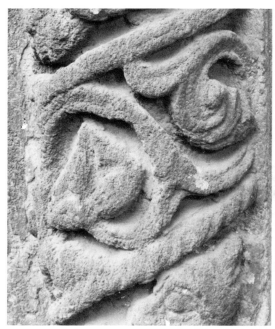
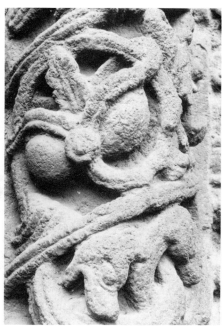

12(a and b).
Two details from
the left jamb of
the Prior's
Doorway at Ely
Cathedral, (a)
showing the
'cone and
pouch' motif

mind that they must be kept in the group we have discussed. Stylistically, they should be placed between about 1135 and 1170 and the fashion of the mitres suggests a date no earlier than about 1150.

It is fascinating to wonder how a Scandinavian workshop producing chessmen of such exceptionally conservative charm, managed to acquire so quickly the very latest ecclesiastical fashion of the day.

It is also intriguing to speculate on how the chessmen got to the remote Isle of Lewis in the Outer Hebrides. All the pieces that are now in Edinburgh and London are complete, and so presumably Lewis was not the site of the workshop. More likely they belonged to some merchant who, travelling by sea or land, lost a part of his stock in circumstances we shall never know.

Bibliography

Blindheim, M., *Norwegian Romanesque Decorative Sculpture 1090-1210,* London, 1965.

Blindheim, M., *Norwegian Medieval Art Abroad,* Exhibition Catalogue, University Museum of National Antiquities, Oslo, 1972.

Dalton, O.M., *Catalogue of the Ivory Carvings of the Christian Era in the British Museum,* London, 1909.

Dalton, O.M., 'Early Chessmen of Whale's Bone excavated in Dorset', in *Archaeologia,* vol.LXXVII, 1928, pp.77-86.

Demay, G. *La costume d'après les sceaux*, Paris, 1880.

Fitz-Edward Hall, ed. *Vasavadatta*, Asiatic Society of Bengal, vol.30, Calcutta, 1859.

Goldschmidt, A., *Die Elfenbeinsculpturen*, vol.IV, Berlin, 1926, Nos.182-228, plates LXIV-LXVIII.

Hohler, E.B., 'The capitals of Urnes church and their background', in *Acta Archaeologica 46*, Copenhagen, 1975, pp.1-76.

Hunter Blair, C.H. *Catalogue of Seals in the Treasury of the Dean and Chapter of Durham*, vol. II, 1411-21.

Lasko, P.E., 'A Romanesque Ivory Carving', in *The British Museum Quarterly*, Vol XXIII, 1960-1, pp. 12-16, plates 8-10.

Liddell, D.M., *Chessmen*, London, 1938.

Madden, F., 'Historical Remarks on the introduction of Chess into Europe, and on the ancient Chess-men discovered in the Isle of Lewis', in *Archaeologia*, vol.XXIV, 1832, pp.203-291.

Murray, H.J.R., *A History of Chess*, Oxford, 1913.

Proceedings of the Society of Antiquaries of Scotland vol. IV, 1863 (Sessions 1860-1, 1861-2). Notes on the Lewis Chessmen by Capt. F. W. L. Thomas, pp.411-413. Vol.XXIII, New Series, 1888-9, pp.9-14.

Royal Commission on Ancient and Historical Monuments and Constructions of Scotland, 9th Report, Outer Hebrides, Skye and the Small Isles.

Wilson, D., *The Archaeology and Prehistoric Annals of Scotland*, Edinburgh, 1851.

Zarnecki, G., *The Early Sculpture of Ely Cathedral*, London, 1958.

(*Right*) Detail from the west door of the stave church at Ulvik, Norway. The 'cone and pouch' motif appears at the lower left corner

(*Back cover*) Decorative panel from a King's throne

Notes in Text

1 Royal Commission pp.23-4 gives precise details of find spot.

2 Madden p.212.

3 Wilson p.567.

4 *Proceedings* 1888-9.

5 Royal Commission pp.23-4.

6 Goldschmidt vol.IV, nos.229-239, plate LXIX. One of these eleven pieces, a bishop, was acquired from the Isle of Lewis after the dispersal of the hoard. Whether this piece was withheld at the time of the original discovery, or was an independent find, does not seem to be recorded. *Proceedings* 1888-9, p.10.

7 *Proceedings* 1863.

8 Fitz-Edward Hall, p.284, For details of translation, see Murray, p.6.

9 Murray, p.374-5.

10 Murray, p.404,419,443.

11 Dalton, 1928.

12 Liddell, p.14.

13 Madden, p.212.

14 Madden, p.248-9 and p.290

15 Lasko.

16 Goldschmidt vol.III, 1923, no.143.

17 Goldschmidt vol.III, 1923, no.142.

18 Lasko.

19 Blindheim, 1965, plates 114-133.

20 Blindheim, 1965, plates 166-7.

21 Blindheim, 1965, plate 179.

22 Zarnecki, plates 20, 23-37, pp.19-23.

23 Zarnecki, plates 38-76, pp.23-6.

24 Blindheim, 1965.

25 Hohler.

26 Zarnecki.

27 Goldschmidt, vol.IV, no.264.

28 Goldschmidt, vol, IV, no.250.

29 Demay.

30 Hunter Blair.

Acknowledgements

The author and publishers are grateful for permission to reproduce the following photographs:

6d,7c National Museum, Copenhagen, Denmark

9a,9b,inside back cover Historisk Museum, Bergen, Norway

10 University Museum of National Antiquities, Oslo, Norway

11,12a,12b Copyright Professor George Zarnecki, by courtesy of the Courtauld Institute of Art.

Sixth Impression 1990

Published by British Museum Publications Ltd, 46 Bloomsbury Street, London WC1B 3QQ

ISBN 0-7141-1347-6

Edited by Judy Rudoe. Designed by James Shurmer. Printed in England by Saffron Press Ltd